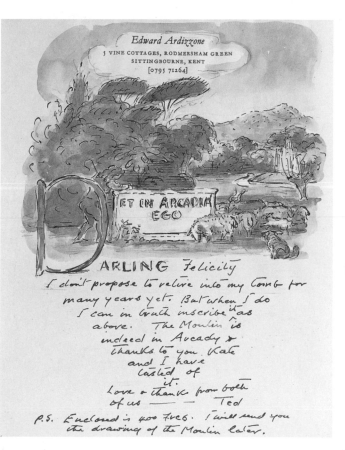

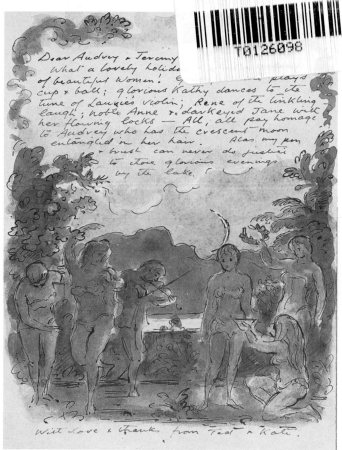

Edward Ardizzone
5 VINE COTTAGES, RODMERSHAM GREEN
SITTINGBOURNE, KENT
[0795 71264]

ET IN ARCADIA EGO

DARLING Felicity
I don't propose to retire into my tomb for
many years yet. But when I do
I can in truth inscribe it as
above. The Moulin is
indeed in Arcady &
thanks to you Kate
and I have
tasted of
it.
Love & thanks from both
of us —— Ted
P.S. Enclosed is 400 Frcs. I will send you
the drawing of the Moulin later.

Dear Audrey & Jeremy
What a lovely holiday
of beautiful women! plays
cup & ball; glorious Kathy dances to the
tune of Lankie's violin; Rene of the tinkling
laugh; Noble Anne & dark eyed Jane with
her flowing locks — All, all pay homage
to Audrey who has the crescent moon
entangled in her hair. Alas my pen
& brush can never do justice
to those glorious evenings
by the lake.

With love & thanks from Ted & Kate.

SKETCHES FOR FRIENDS

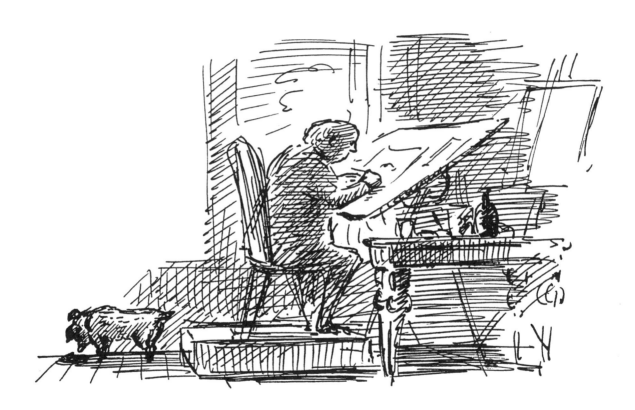

Edward Ardizzone

Sketches for Friends

CHOSEN AND INTRODUCED BY

Judy Taylor

DAVID R. GODINE · Publisher

BOSTON

FIRST U.S. EDITION PUBLISHED IN 2002 BY
David R. Godine, Publisher
Post Office Box 450
Jaffrey, New Hampshire 03452
www.godine.com

Introduction and selection copyright © 2002 by Judy Taylor
Illustrations copyright © 2002 by The Ardizzone Estate

LIBRARY OF CONGRESS
CATALOGING-IN-PUBLICATION DATA
Ardizzone, Edward. 1900–1979
Sketches for friends / Edward Ardizzone ;
chosen and introduced by Judy Taylor. — 1st ed.
p. cm.
Originally published: London : John Murray, 2000
ISBN 1–56792–185–x (hardcover, alk. paper)
1. Ardizzone, Edward, 1900–1979—Notebooks, sketchbooks, etc.
2. Ardizzone, Edward, 1900–1979—Correspondence.
I. Taylor, Judy, 1932– II. Title
NC242A69 A4 2002
741.942–dc21 2001040859

FIRST U.S. EDITION 2002
Printed in Canada

In memory of
the late Dick Hough with love

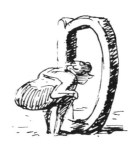

letters on the front endpapers:

TO SUSANNAH CLEMENCE, 1958
TO MICHAEL BEHRENS, 1958
TO FELICITY BEHRENS, 1966
TO AUDREY AND JEREMY HARRIS, 1965

letters on the rear endpapers:

TO MICHAEL BEHRENS, 1973
TO MICHAEL BEHRENS, 1974
TO MICHAEL BEHRENS, 1967
TO MICHAEL BEHRENS, 1959

CONTENTS

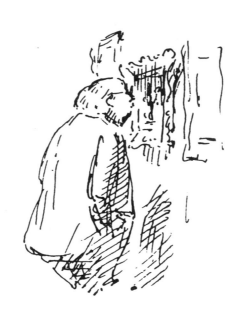

INTRODUCTION

EARLY IN 1993 I started to collect the letters of Edward Ardizzone, whose drawings and paintings I have long admired. The attractive biography of him by his brother-in-law Gabriel White, published in 1979, had been out of print for some years and, as there was no sign of it being reprinted, I felt that perhaps it was time for Ardizzone's story to be told again, and that it might be possible to do so in his own words through a selection of his letters. My first stroke of luck was to discover that the Ardizzone family had kept not only the letters he had sent them since childhood and his first letters to their children, but also the letters he had written during the war to Catherine, his wife for fifty years. I then approached his friends and his publishing contacts for any letters they might have, and I appealed for others through the pages of the *Times Literary Supplement* and the book pages of *The Sunday Times*.

The response was remarkable and the pile of letters grew, but it soon became clear that the reason many people had treasured Ted's letters over the years was because of the wonderful sketches in them — or, in some cases, because of their remarkable watercolours. So, to mark the centenary of his birth, I made a selection of the sketches from his letters, including a number of his watercolour letters (pp. 65–80), and his fantasy Snodgrass Letters (pp. 121–7). I also selected some of his little-known drawings from *A Diary of a Holiday Afloat* (pp. 35–50), which originally appeared in *The Saturday Book, No. 11, Visiting Dieppe* (pp. 81–92), privately published in 1951, and *A Day Out at Glyndebourne* (pp. 103–10), drawn for the Royal College of Art *Cellar Notes* in 1956.

Edward Ardizzone's distinctive watercolours and lithographs, his drawings for the *Radio Times*, *Lilliput*, *Punch*, and *Strand* magazines have been familiar to many people since the 1930s. For the majority their first encounter with his work may well have been

through his unrivalled series of children's picture books about Tim. Although *Little Tim and the Brave Sea Captain* was published in 1936, Edward Ardizzone had begun his illustrating career eight years earlier, when he was commissioned by Peter Davies to provide the drawings for Sheridan Le Fanu's *In a Glass Darkly*. It was the start of a lifetime of illustration which would continue for the next fifty years and would ultimately produce over two hundred books.

Edward Ardizzone was born on 16 October 1900 in Haiphong, now in Vietnam but then in the Tonkin province of French Indo-China. He was the first son of a Scottish mother, Margaret Irving, and of her husband, Auguste, a naturalized Frenchman of Italian parentage who was working for the Eastern Telegraph Company. In 1905, the Ardizzones decided that it would be best for Edward and his two younger sisters, Betty and Tetta, to be brought up and educated in England, so Margaret travelled with them to East Anglia, where they lived in a number of different houses, for much of the time in care of their formidable grandmother, while their mother returned to China to be with her husband — and to have another two sons, David and Michael.

After a spell of lessons with a governess, the young Edward was sent to Ipswich Grammar School, where he sought to escape from the serious bullying by "scribbling over my lesson books." Relief for him came in 1912 when the family moved to Wokingham and Edward became a boarder at Claycsmore School. It was at this school, an educational establishment thought to be slightly unorthodox and even somewhat advanced for the time, that Edward's artistic talents were recognized and encouraged by a sympathetic teacher. The boy had undoubtedly inherited his talent for drawing from his mother who had studied painting in Paris at Colorossi's in the 1880s but, when the time came for him to leave school, art was not considered by his family to be a suitable profession for a grown man and his father had no intention of finding the money for art school.

So in 1918 the young Ardizzone was sent to a commercial college in Bath, where he acquired the skills of shorthand and typing and conquered the

mysteries of bookkeeping, subsequently enabling him to find work as a clerk. Also in 1918 his father returned from the Far East and bought a large house in London, 130 Elgin Avenue, Maida Vale, which for the next fifty years was to be the Ardizzone family home.

Throughout the seven years that Edward Ardizzone worked for the Eastern Telegraph Company, he continued to draw, "spending hours as an idle clerk in a City office doodling little drawings over and over again until I thought they looked right" and then pasting them into an exercise book when he got home. He also took the significant step of attending Bernard Meninsky's life classes, which were held in the evenings at the Westminster School of Art. In 1926, a gift from his father of £500 released Edward from his secretarial duties and allowed him to make his first long visit abroad. More importantly, he was at last able to become a full-time artist, painting in both oil and watercolour.

In 1929 he married Catherine Anderson, whom he had met the year before at a dance at the West-minster School of Art, and they moved into the family home in Elgin Avenue where their first child, a daughter Christianna, was born. That same important year Ardizzone's first book illustrations were published, but as no more commissions followed "the full-time artist" soon discovered that it was not going to be easy to support a family.

In 1930, Ardizzone had his first one-man exhibition, at the Bloomsbury Gallery, and although he sold not a single picture it was an auspicious occasion, for one of the visitors to the gallery was a childhood friend, Maurice Gorham, who was then the art editor of the *Radio Times*. Gorham commissioned his old acquaintance to draw regularly for the paper, a connection that would continue well into the 1940s and bring his work to the attention of a large and appreciative public.

Between 1931 and 1936, the Leger Gallery held five exhibitions of Ardizzone's work and in 1936 the first "Tim" book was published, dedicated to Ardizzone's five-year-old son, Philip. A new book in the series would follow in each of the next two years.

At the beginning of the Second World War, Ardizzone served in an anti-aircraft battery on Clapham Common. Then early in 1940, without warning and somewhat to his surprise, he was appointed an Official War Artist by Sir Kenneth Clark and attached to the British Army's GHQ at Arras. Those first months in France had an important influence on his work, broadening his outlook, even changing his style, for it was necessary to get his images down on paper at speed and with accuracy. He met and became lifelong friends with his fellow war artists, Barnett Freedman, Edward Bawden and Anthony Gross, and after that first attachment in France, he saw service in North Africa, Sicily, and Italy. In France again in 1944 for the Normandy landings, he was in Germany in 1945 as the war in Europe came to an end. Throughout his time as a war artist Ardizzone kept a diary, large parts of which were published in 1974 as *Diary of a War Artist*, and many of his drawings and sketches from it were the basis for nearly four hundred of his works, over three hundred of which are now housed in the Imperial War Museum in London. Even while fulfilling his duties as a war artist, Ardizzone found time to fit in some commercial work, providing drawings for the *Strand* magazine and even illustrating Walter de la Mare's *Peacock Pie* while he was on leave in Cairo in 1945.

His first post-war exhibition was at the Leicester Galleries in 1948, the same year in which he started to teach at the Camberwell School of Art, and over the next few years he had regular and increasingly successful exhibitions of his pictures, both paintings and lithographs, of London life, the pubs, the parks and the recreation grounds in the district near his home in Maida Vale. In 1952 he was invited by UNESCO to teach classes in silk-screen printing at a seminar for the production of audio-visual aids in Delhi and Bombay, a task he willingly undertook but for which he admitted he was not well qualified — "I have had to mug it all up out of a book." His trip resulted in another wonderful diary, his written entries fully augmented by sketches in pencil, ink and watercolour and published in 1984 as *Indian Diary 1952–53*.

Ardizzone was increasingly in demand as an illustrator, particularly of the books for children by James Reeves and Eleanor Farjeon, and in 1956 his latest picture book, *Tim All Alone*, was awarded the British Library Association's Kate Greenaway Medal for "the most distinguished work in the illustration of children's books". He was much admired as a painter and in 1962 was elected Associate of the Royal Academy and in 1970 as a Royal Academician.

In 1972 Edward and Catherine left Elgin Avenue to live permanently in the cottage in Kent they had bought six years before. Though the move marked the end of a long and successful London life it also heralded the start of regular and bibulous lunch parties in his studio in the garden. There were still exhibitions of his work in London, and Ardizzone made the occasional journey to visit the city with which he was so closely identified but, after a fall and a spell in hospital, his life took on a slower pace and he died at his home in Rodmersham Green in Kent in November 1979.

The letters from which the sketches in this book are taken span more than forty years. All those in the first section are to his family, his wife Catherine, his children Philip, Christianna (later Clemence) and Nicholas Ardizzone. The second section includes pictures from letters to his American fan Bernard Meeks, to the author James Reeves and to an old friend, Jose Baird. The watercolour letters are to his nephew Antony White, to his grandchildren Susannah and Quentin, to his cousin Christianna Brand, to friends Audrey Harris and Julia and Ted Whybrew — and to Michael Behrens.

Ted first met Felicity and Michael Behrens in the 1950s when he was recommended to them as the artist to draw their annual Christmas card, something he was to do regularly for many years. The two families became close friends, the Ardizzones being popular weekend guests at the Behrens's family home, Culham Court, near Henley-on-Thames, and at the houses they took for the summer in Majorca and the south of France. Ted's thank-you letters for these holidays — and for the regular Christmas presents of good wine — provided the ideal opportunity

for fine examples of his watercolour letters with their beautifully decorated initial letters.

The last two sections of this work again include sketches from Ardizzone's letters to his family and friends, but also to his publishers, John Bell, Grace Hogarth and myself. The book ends with a small selection from his Snodgrass Letters, an entertaining and imaginary correspondence with which he amused himself in the 1960s. Mainly to be found in his sketchbooks (now in the Ashmolean Museum) these are letters written to a Mr Snodgrass, the publicity manager of a firm of corset manufacturers, and signed with a variety of names, including John Podsnap, Christopher Wrench and Ernest Binks.

The familiar and avuncular figure of Ardizzone himself features in many of his letter sketches. Seeing him again will be a reminder to many of his gentle manner, his infectious enthusiasm — and of his ever-present snuff. His sketches are fine examples of his exquisite drawing and his particular humour.

* * *

Ardizzone in the U. S.

IT WAS ENTIRELY DUE to the advance of printing technology in the United States of the 1930s that Edward Ardizzone owed his long and successful illustration career. When the Oxford University Press in England received the drawings for Ardizzone's first ever picture book for children in August 1935, they sent it at once to their office in New York "to see if it were possible to reproduce it economically." Happily it was possible and *Little Tim and the Brave Sea Captain* became one of the earliest children's picture books to be printed by what was then called four-colour offset lithography.

Edward Ardizzone's special connection with the United States continued until his death over forty years later, by which time he had illustrated over one hundred and fifty books for children and for adults. Nearly all had US editions and the illustrations for some had been directly commissioned by New York editors — titles by such authors as Eleanor Estes, Jan Wahl and Eva-Lis Wuorio. A

number of Ardizzone's original book illustrations are now in the de Grummond Collection at the University of Southern Mississippi and in the Kerlan Collection at the University of Minnesota.

Ardizzone crossed the Atlantic only a few times — always by boat — and when he did he usually stayed with the family of his New York editor and friend, Pat Lord, and her husband, Beman. It was their guest's taking of snuff that most impressed Pat's young son, Ted — who became "Little Ted" while "Big Ted" was in the house. "I distinctly remember him sitting in the yellow chair after breakfast one morning. I watched as he produced a silver filigreed box and a large pocket-square. He then proceeded to take a small pinch of some ochre substance and snort it into each nostril. He waited patiently (and silently to my storm of little-boy questions), and then he gave several loud and seemingly satisfied sneezes. He then folded up his handkerchief and gave me a watery smile."

Ann Beneduce, then editor-in-chief at The World Publishing Company and for long an admirer of Ardizzone's work, recalls the time she was invited to his house in London in the 1960s. On the evidence of his name only she had expected to meet "a dashing young Italian, not the rather portly, grey-haired, decidedly British gentleman" who answered her ring at the bell. He was also expecting someone of Italian extraction, though Ann was "a young American of Welsh and Scottish descent" who had at one time been married to an Italian-American.

Once over the mutual shock they both settled down to talk and to tea and afterwards Ann watched as Ardizzone sketched a child that they could see in the garden beyond the window. "No outlines: instead his pen steadily scratched a sort of ball made of many lines. Then, still continuously scratching, it now added just a suggestion of a leg, two legs, an arm, another arm, and a head. All the while he was watching the little girl intently, and at the same time was feeling out with his pen the pose, the gesture, the particular charm of the character that began to appear in the sketch almost of its own accord. Some more concentrated scratches for shadows, for model-

ling — and there it was, a small masterpiece, completed in just a few minutes, but with the skill acquired of a lifetime of drawing."

For Ann Durell, then editor at Holt, Rinehart and Winston, it was a matter of recalling "one prototypical English/American usage problem." She had commissioned Ardizzone to illustrate a story in which peanut butter and jelly was mentioned. When the finished drawings arrived (he never bothered to send roughs) one of the pictures showed "a moulded pudding beside a jar of peanut butter, giving the 'jelly' its British definition to what we Yanks call 'Jell-o'." Unusually for Ardizzone, it was a drawing that he had to do again.

When I was seeking out Ardizzone letters to prepare for this book I was at a loss to know where to look in America until I was advised that the de Grummond Collection at the University of Southern Mississippi might well be a likely source. Founded in 1966 by Dr. Lena Y. de Grummond, it is a remarkable collection of the manuscripts, letters, illustrations, and books of more than 1,200 authors and illustrators, with its main focus on American and British children's literature. Here is a treasure trove of Ardizzone material. Together with a number of original illustrations, there are twenty-one letters written by the artist between August 1945 and December 1952 to a devoted fan, Bernard M. Meeks, a collector of children's books and original artwork who was in the United States Navy. As well as discussing his current work, Ardizzone's letters are full of appreciation and thanks for the regular parcels that Bernard Meeks was sending to the Ardizzone family at a time of severe food rationing in the UK.

Edward Ardizzone's work is much admired and collected by people all over the world. To mark the centenary of his birth in the year 2000 there were exhibitions and celebrations in many places — including Moscow. This distinguished artist's work will, without doubt, continue to be fondly remembered and treasured for many years to come.

— Judy Taylor
London

SKETCHES FROM LETTERS

1935–1949

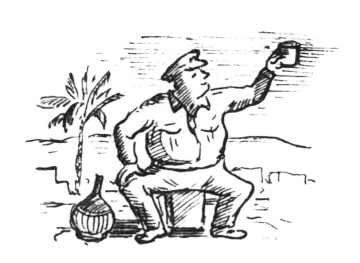

We boys are having a splendid time. We have breakfast in our dressing-gowns in front of the studio fire — porridge & coffee.

TO CATHERINE ARDIZZONE, C. 1935

When you want to draw boys
it is great fun to make them
as ugly as possible, like this.

TO PHILIP ARDIZZONE, C. 1935

17

The nasty Prefect

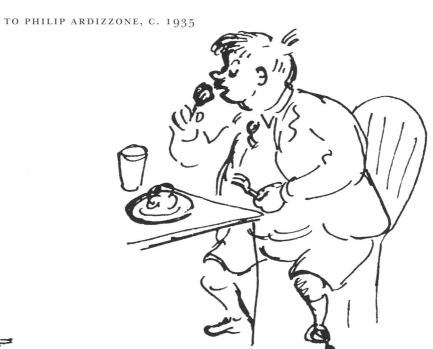

Old greedy guts

When you next write to me
you must address the envelope
to Capt. Edward Ardizzone.
Here I am with all my pips up. . .

. . . I have made myself look
much too fat in the drawing —
actually I look quite like this.

TO PHILIP ARDIZZONE, C. 1940

At the Bank a large bomb has fallen into the middle of the tube station, and all there is of it now is a vast hole filling all the road way. . . . I wish I could describe [the ruins] but is it impossible. Here is a little drawing which might give you some idea.

TO CATHERINE ARDIZZONE(?), C. 1940

You would be surprised if you were here [in Egypt]. All the little boys wear little round caps and long clothes like night-gowns, the men do too. The women wear black veils and carry their children on their shoulders.

TO NICHOLAS ARDIZZONE, 1942

20

*I was in Alexandria a little while ago and I
spent a lot of time on the sea shore watching the
fishermen catch little fishes in their nets. Here is
a picture of one emptying his net . . . and below
is a drawing of him dragging his net to the shore.*

TO NICHOLAS ARDIZZONE, 1942

21

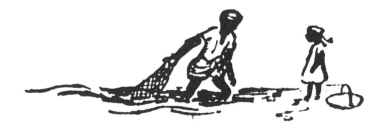

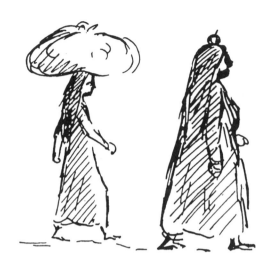

The women and girls carry everything on their heads. Sometimes it is really rather comic, as you will see a very small girl with an enormous bundle and then a big fat woman with nothing but an apple perched like a pimple on top of her head...

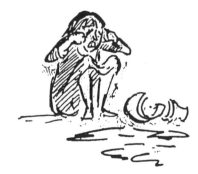

... I saw a very sad sight — a very small girl ... with a large broken pitcher on the ground in front of her and milk all over the place.

TO CHRISTIANNA ARDIZZONE, 1942

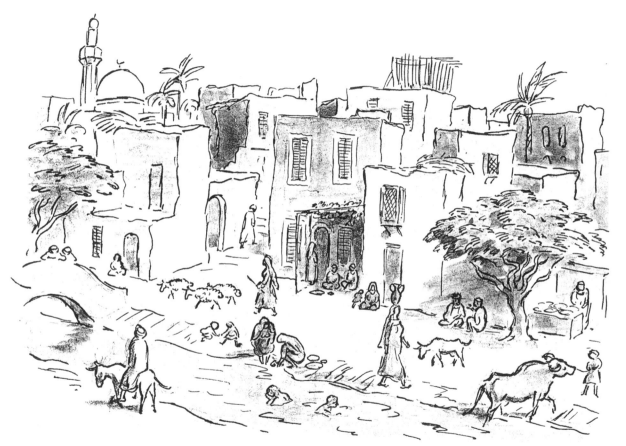

Here is a picture of a small Egyptian town. This is a funny tumbledown-looking place.

TO NICHOLAS ARDIZZONE, 1943

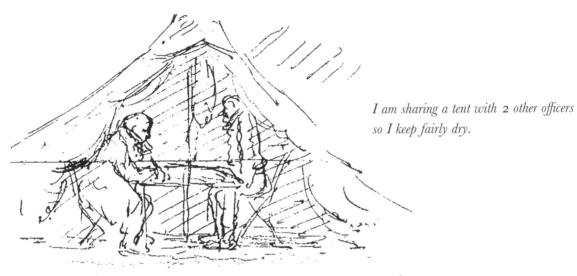

I am sharing a tent with 2 other officers so I keep fairly dry.

24

Edwards, my driver, has been teaching me to drive the Jeep.

TO CATHERINE ARDIZZONE, 1943

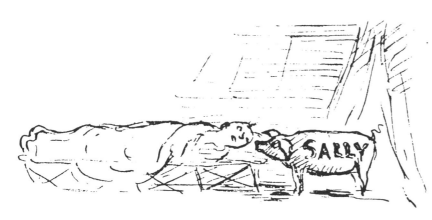

*Our camp is rather like
a farmyard now...*

*... as the soldiers have brought a
fat pink piglet, 4 turkeys, 6 hens
and two absurd little puppies.*

TO NICHOLAS ARDIZZONE, 1943

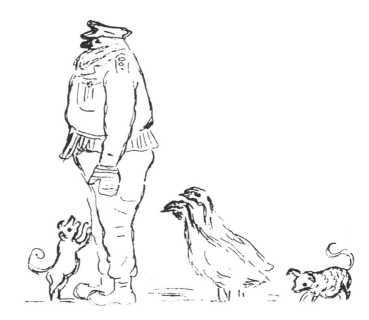

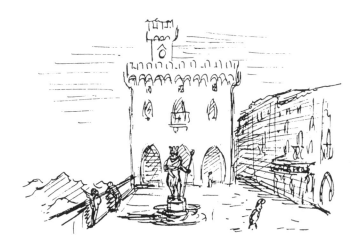

The second visit to San Marino was in lovely weather....
This is the main piazza with its absurd Victorian gothic
Town Hall at the end and a sort of Victorian King Stephen
in white marble at the centre.

26

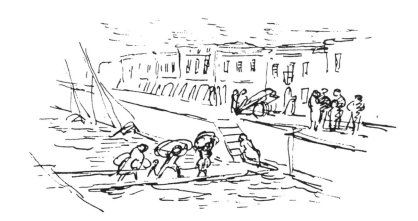

Cesenatico is a delightful little fishing town....
I amused myself making notes of [the inhabitants]
crossing [the floating bridge] carrying bundles of
bedding back to their homes.

TO CATHERINE ARDIZZONE, 1944

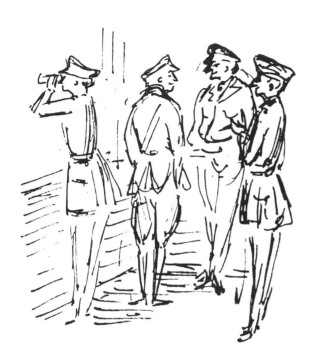

*The young officers of the Lancer Regiments
were there [at the Cesena Races] in force
and all dressed in immaculate clothes. . . .
If you are very young and beautiful you don't
get a Military Hair Cut but grow your hair
in tasteful curls as below. . .*

*. . . Age probably 20,
plus a D. S. O. or M. C.*

TO NICHOLAS ARDIZZONE, 1945

*I am now living with a famous tank Regiment.
I live and travel in, on and by a tank. Yesterday
we moved eastward in a great armoured column,
rumbling through open farming country...*

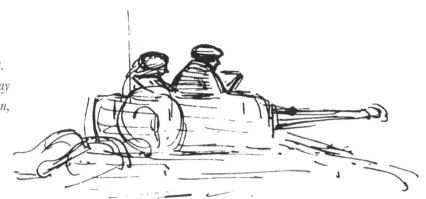

28

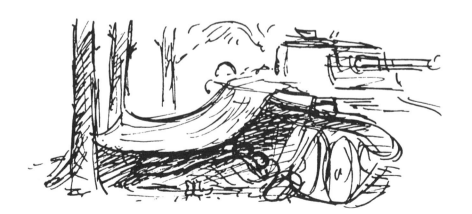

*...I sleep with my tank crew under a
tarpaulin rigged from the side of the tank.*

TO CATHERINE ARDIZZONE, 1945

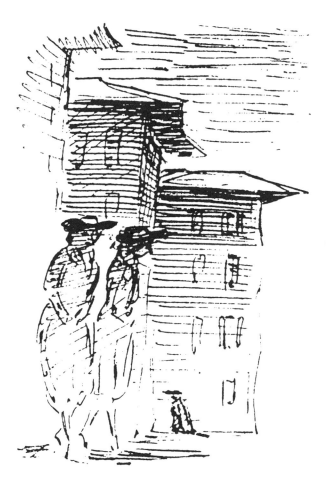

[Florence] has a somewhat black and dramatic quality which is due to the narrow streets and the tremendous jutting eaves. . . . Many of the women wear flat hats which make an odd note of repetition with the eaves.

TO CATHERINE ARDIZZONE, 1945

29

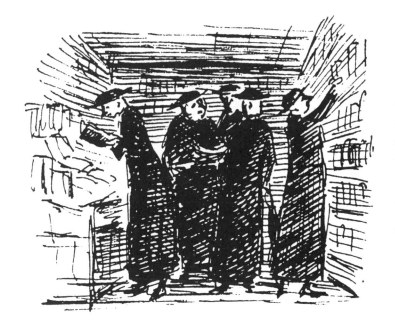

30

Much of the time I have spent wandering about Rome with Bawden, another War Artist. . . . Very often, in the corner of some little square or tucked in beside some great church, one will find clerical book shops full of black clothed priests in flat hats and cassocks gossiping or examining the books.

TO PHILIP ARDIZZONE, 1945

I am not sending you a birthday present
as you are to have a bicycle for Xmas.
The bicycle will not be entirely yours...

TO PHILIP ARDIZZONE, C. 1948

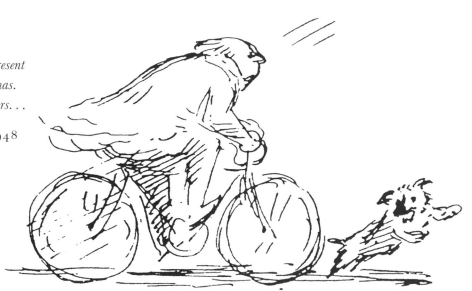

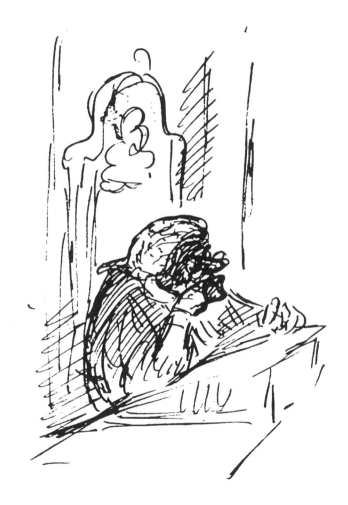

At Quarter Sessions a Recorder presides over
the court not a judge. The one we had looked
a terrible old man, bent with rheumatism
and mouthing and grimacing with some
sort of St. Vitus's dance.

TO PHILIP ARDIZZONE, C. 1949

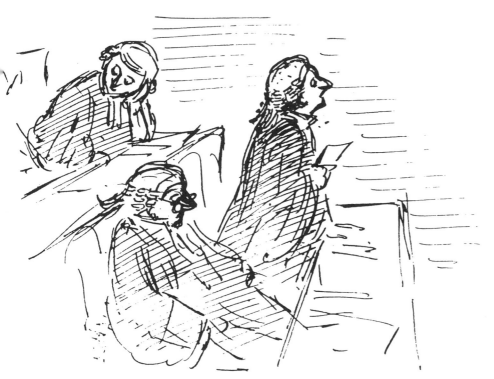

Today has been my last day as a Juror at Newington Quarter Sessions.... I hope to capitalise on my experience with a number of Law Court drawings.

TO PHILIP ARDIZZONE,
C. 1949

33

I have taken part share in a minute room in
a cellar with a litho press in it. I think
I have produced two tolerable ones to date.

TO PHILIP ARDIZZONE, C. 1949

34

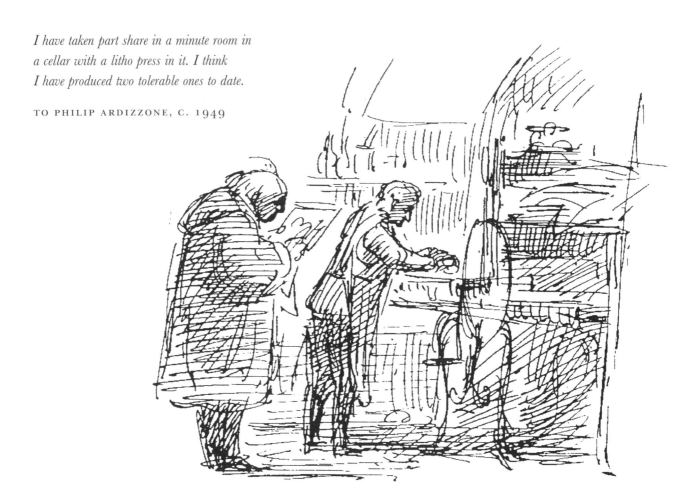

A Diary of a Holiday Afloat

1951

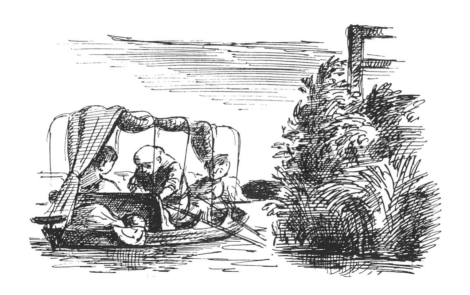

TUESDAY

*Leave Lechlade in the afternoon. The weather lovely,
the river winding among flat fields, its banks high
and covered with flowers.*

*Successfully negotiate our first two locks and moor
for the night at an island by a weir.*

It rains before dark.

*Three in a boat too many.
The mattress hard and I
long for morning.*

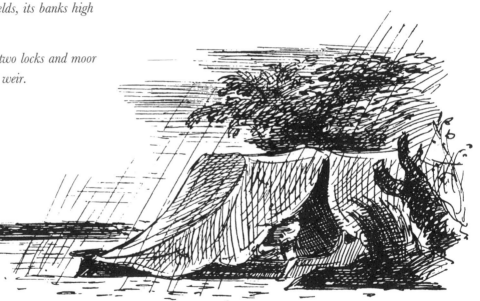

Primus trouble

38

WEDNESDAY

Fine calm morning. Visit Kelmscott village where Nicholas buys a rod & line.

Our journey much delayed as Nicholas insists on acting as amateur Lock Keeper at every lock we pass.

Moor for the night near Radcot bridge.

Drink some much needed pints of
beer at the Swan.

Pitch the small tent and so spend
a more comfortable night.

*Decide that there is a sinister
quality about locks that
we don't get used to.*

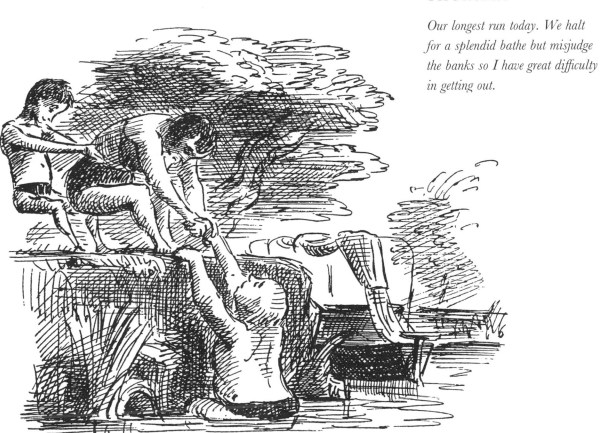

THURSDAY

Our longest run today. We halt for a splendid bathe but misjudge the banks so I have great difficulty in getting out.

Lunch near the Trout Inn and tea
at the 'Rose Revived' where we are
somewhat intimidated by the smart
yachts and even smarter crowd.

However we find a more secluded
mooring place & return there for
a most expensive dinner.

We make friends with a yachtsman
and his wife and Catherine and I drink
rum with them on board their craft
till late. Sleep well in consequence.

44

FRIDAY

Warm and sunny.
We idle most of the day
in a pleasant backwater.

Our meals made interesting
if somewhat hazardous by
a party of voracious swans.

Shop in Northmoor village in the afternoon then drop down stream for a short way to find a good camping ground among some willows.

We pitch the tent and light a wood fire on which we cook our supper and sit round it after dark.

45

46

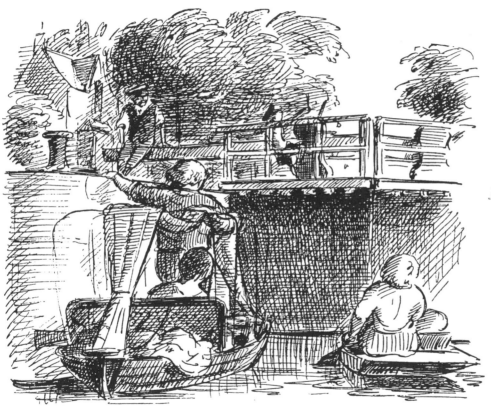

Nicholas works the Lock.

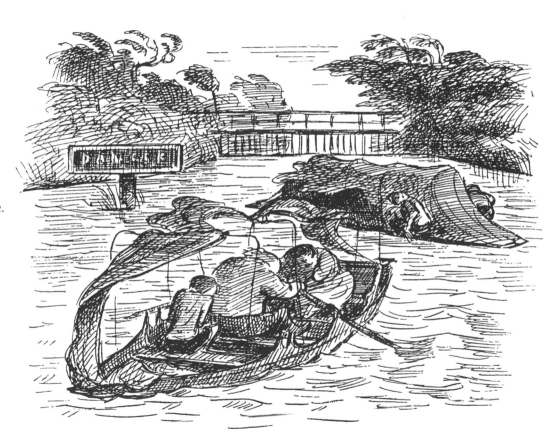

SATURDAY

Wind and then rain.

47

Spend a dampish night
somewhere below
48 *Bablock Hythe.*

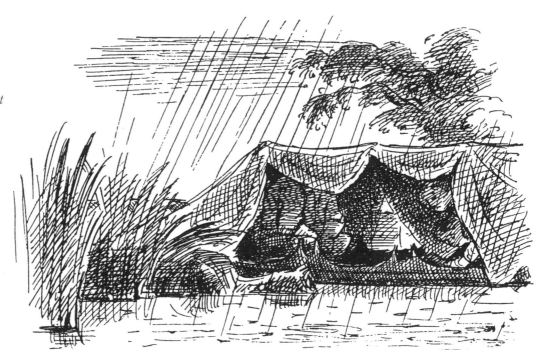

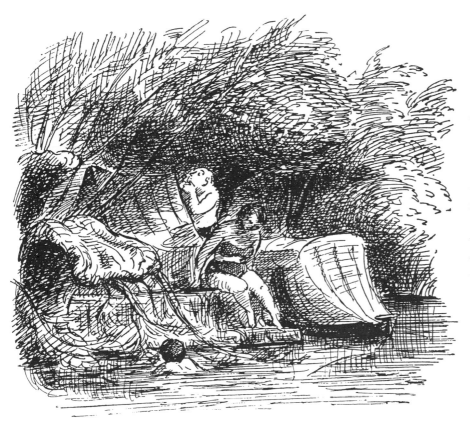

SUNDAY

Glorious weather again.
The morning spent in drying out,
tidying and paying a visit to a
nearby pub for liquor.

In the afternoon we find the ideal
site and stay there. We bathe and
idle till dark.

49

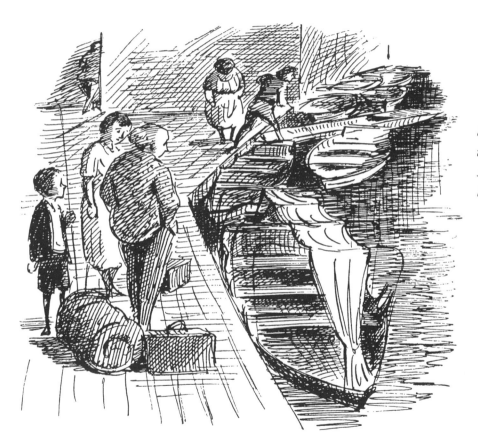

50

Successfully negotiate the narrow waters in the city and arrive safely at Salters Yard where we bid a sad farewell to our craft.

The End

SKETCHES FROM LETTERS

1950–1953

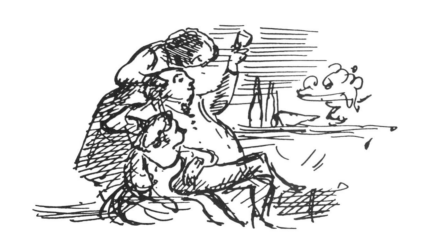

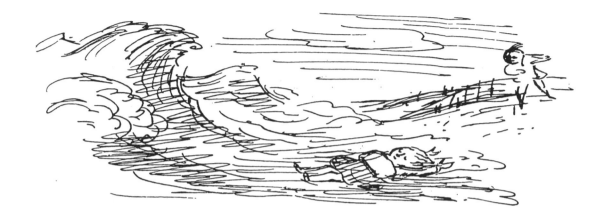

I am now at work on a new Tim story [Tim and Charlotte] *and this drawing is a foretaste of it. The story opens with this scene. The little girl is not dead. She wears a life belt, and from now on the drama mounts swiftly...*

... Charlotte is a new character. I think and hope you will like her.

TO BERNARD MEEKS, 1950

This morning a real promise of spring, with
the tenderest of blue skies, soft sunshine and
a little wind from the west.... There will be
a storm of rain when I go to lunch. What hell.

TO PHILIP ARDIZZONE, 1951

53

*There is a mousehole behind the low
platform I sit on (to keep my feet
out of the draughts) and my old dog
spends much of his time sniffing deep
sniffs at it. I think he believes he can
Hoover the mice out if he sniffs
hard enough.*

TO JAMES REEVES, 1952

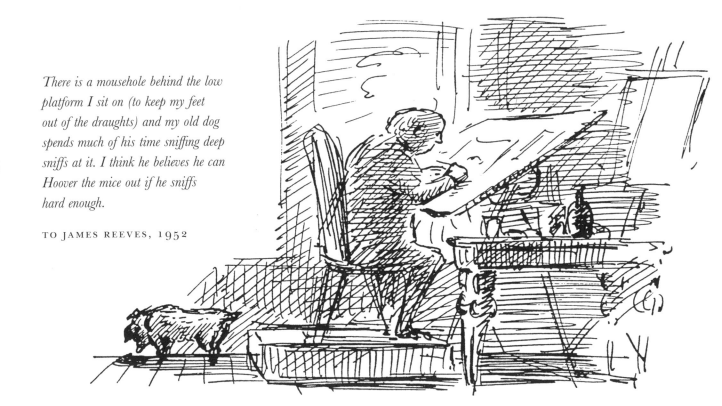

I am at the moment, as well as other things,
trying to paint a series of enormous panels
for a church [in Faversham].

TO BERNARD MEEKS, 1952

My room [in Constitution House in Delhi] is in a one storey building with an arcade down one side. . . . I have to thread my way through chairs, tables, beds and all sorts of junk which even includes some hutches full of rabbits near my door.

TO NICHOLAS ARDIZZONE, 1952

56

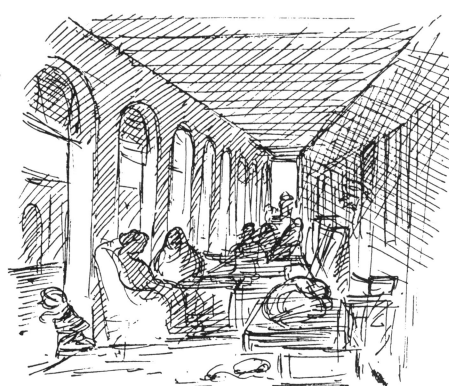

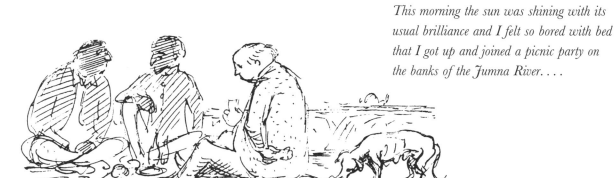

This morning the sun was shining with its usual brilliance and I felt so bored with bed that I got up and joined a picnic party on the banks of the Jumna River....

57

... Here the Delhi people like to come and take the air.

TO NICHOLAS ARDIZZONE, 1952

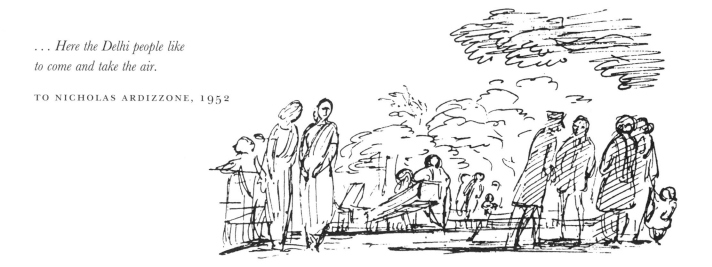

On the way home we saw a countryman
leading a large black bear.

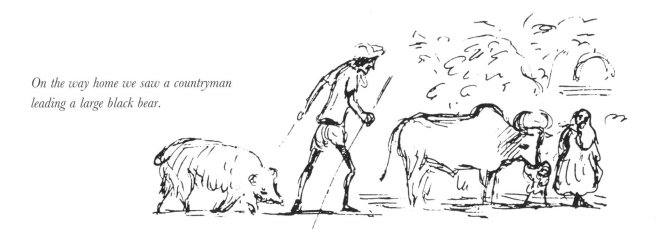

58

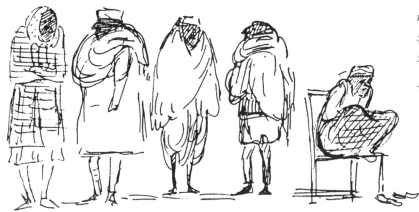

The Indians seem to feel the cold very
much and during these times one sees many
strange figures wrapped up in blankets,
shawls, mufflers and pullovers.

TO NICHOLAS ARDIZZONE, 1952

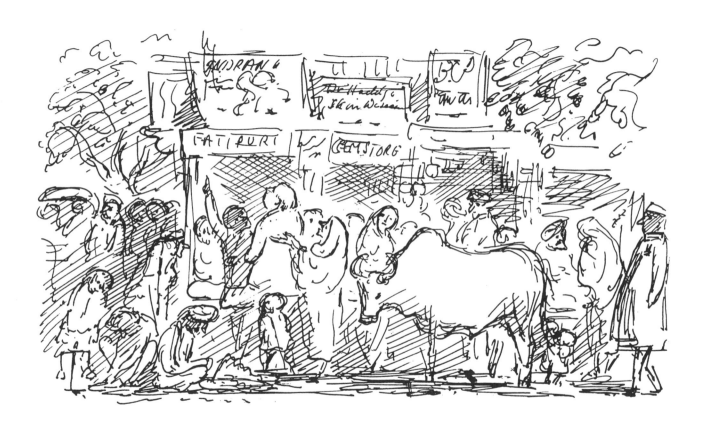

Myself shopping in the Bazaar. The white bulls are luckily very tame.

TO CHRISTIANNA CLEMENCE, 1952

It has become much colder with the result that I caught a chill and had to retire to bed. . . . All sorts of people kept knocking at my door . . . and finally a terrible dark fellow kept peering at me through the glass.

TO NICHOLAS ARDIZZONE, 1952

60

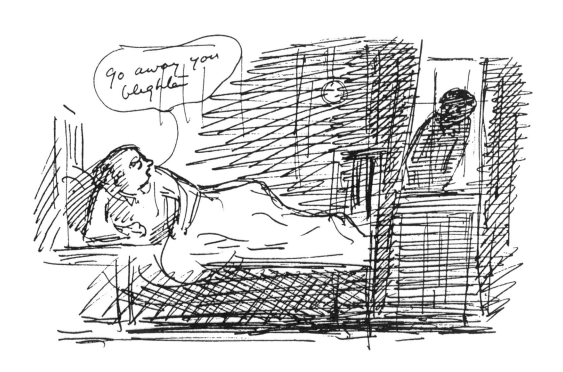

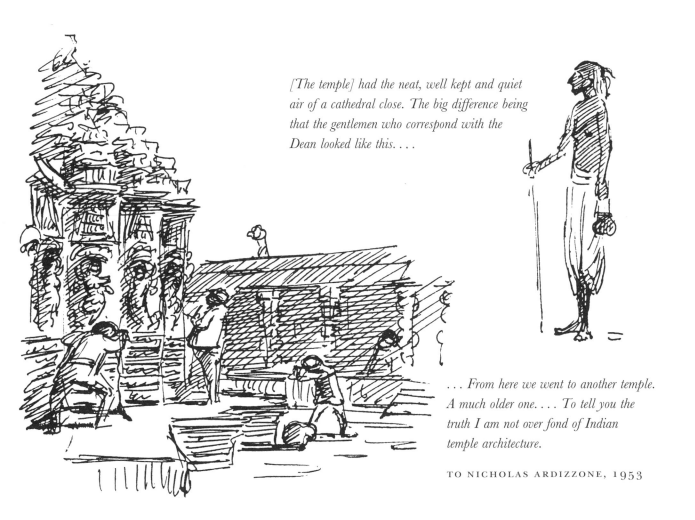

[The temple] had the neat, well kept and quiet air of a cathedral close. The big difference being that the gentlemen who correspond with the Dean looked like this....

... From here we went to another temple. A much older one.... To tell you the truth I am not over fond of Indian temple architecture.

TO NICHOLAS ARDIZZONE, 1953

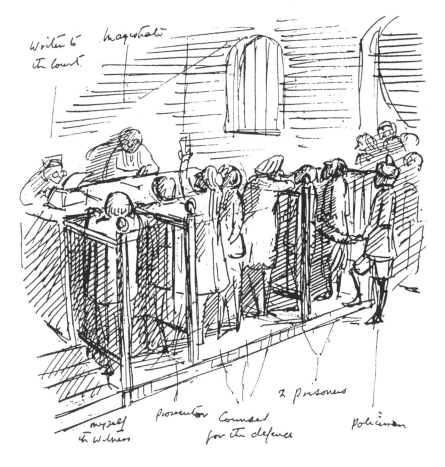

Written to
the court

Magistrate

myself
the witness

Prosecutor

Counsel
for the defence

2 prisoners

Policeman

62

The Delhi police are very pleased with themselves, as not only did they catch the thieves that stole my property but they also got it back.

TO NICHOLAS ARDIZZONE, 1953

The accused, two formidable looking ruffians,
were led into court chained to a policeman.

63

I was severely cross examined by counsel
for the defence, who tried to make out that
my watch with my initials on the back
could easily be bought in the bazaar.

TO CATHERINE ARDIZZONE, 1953

64

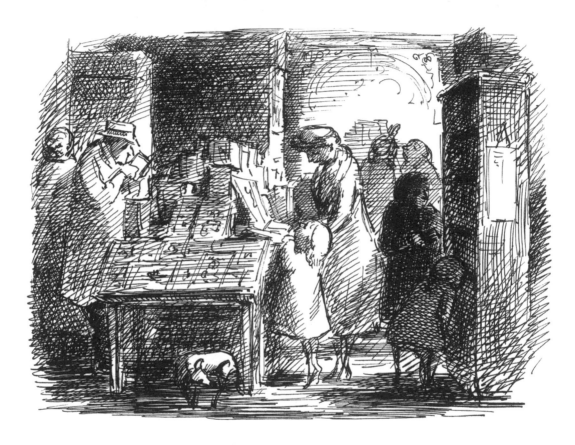

I have been trying to find a book for my godson recently.
It is rather a nice book shop, don't you think?

TO JOSE BAIRD, 1953

Letters in Colour

1944–1975

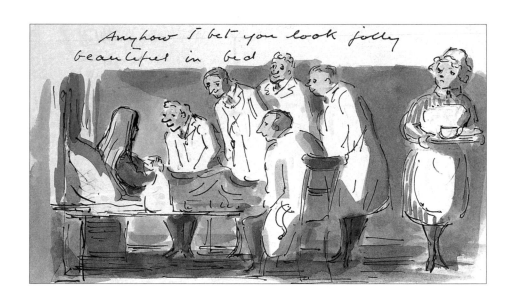

Best Wishes for Xmas

The A.F.P.U. Farmyard takes a hand.

66

THIS PAGE:

TO ANTONY WHITE,

1944

PREVIOUS PAGE:

TO VICTORIA LEWIS,

1968

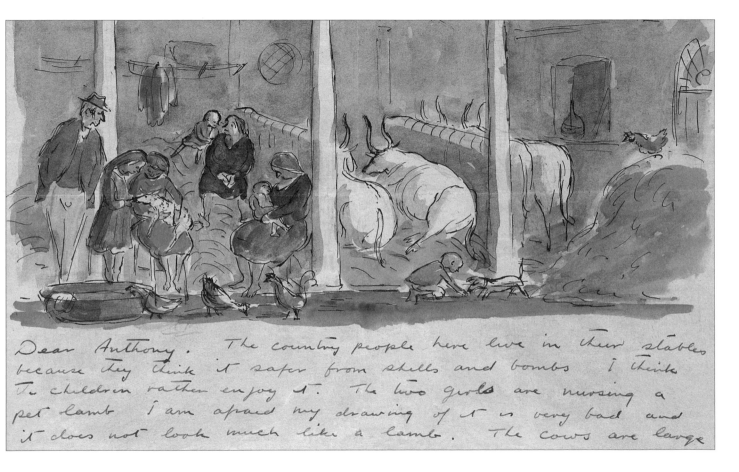

Dear Anthony. The country people here live in their stables because they think it safer from shells and bombs I think the children rather enjoy it. The two girls are nursing a pet lamb I am afraid my drawing of it is very bad and it does not look much like a lamb. The cows are large

TO ANTONY WHITE, 1944

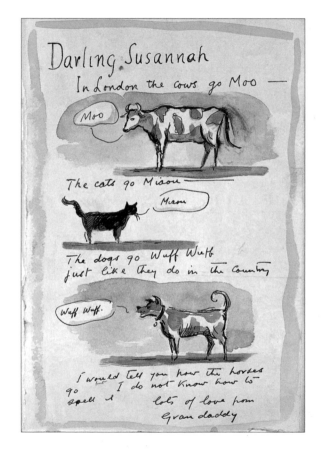

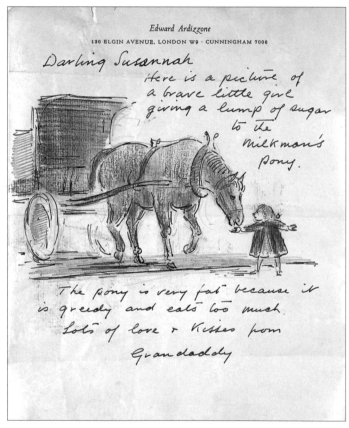

TO SUSANNAH CLEMENCE, C. 1955

TO SUSANNAH CLEMENCE, 1956

TO MICHAEL BEHRENS, 1956

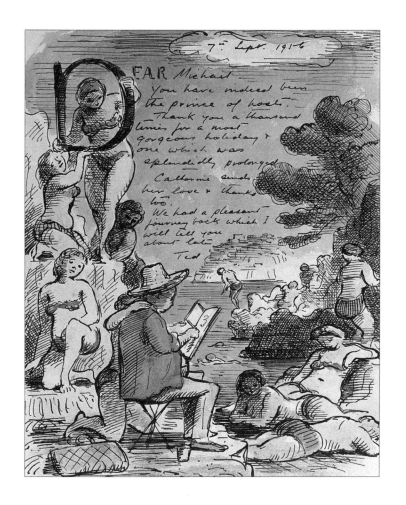

The letter reads:

7th Sept. 1956

DEAR Michael
You have indeed been
the prince of hosts.
Thank you a thousand
times for a most
gorgeous holiday &
one which was
splendidly prolonged.
Catharine sends
her love & thanks
too.
We had a pleasant
journey back which I
will tell you
about later.
Ted

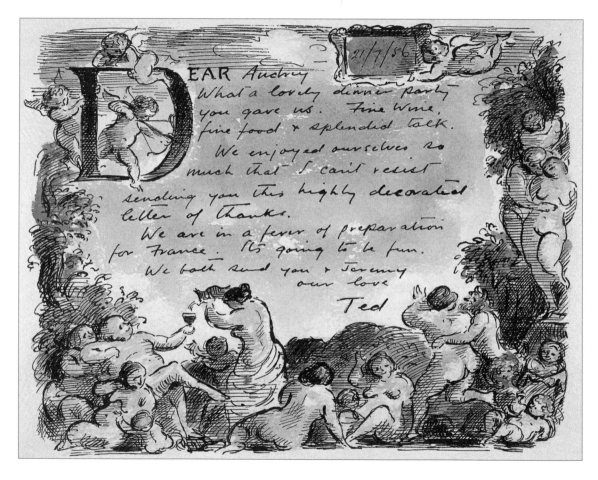

DEAR Audrey

What a lovely dinner party you gave us. Fine Wine, fine food & splendid talk.

We enjoyed ourselves so much that I can't resist sending you this highly decorated letter of thanks.

We are in a fever of preparation for France. It's going to be fun.

We both send you & Jeremy our love

Ted

21/7/56

TO AUDREY HARRIS, 1956

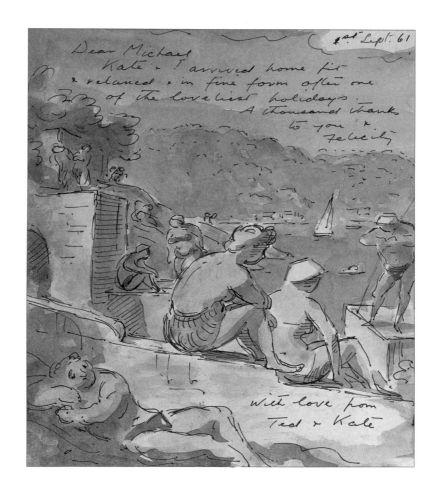

Dear Michael
 Kate & I arrived home fit
& relaxed & in fine form after one
 of the loveliest holidays.
 A thousand thanks
 to you &
 Felicity

With love from
Ted & Kate

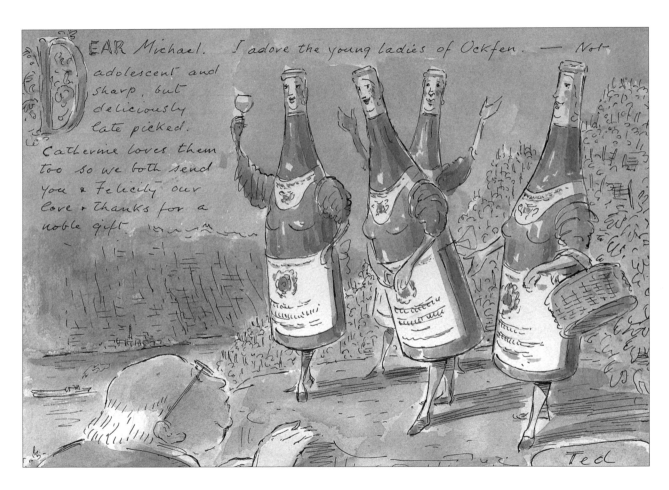

DEAR Michael. I adore the young ladies of Ockfen. — Not adolescent and sharp, but deliciously late picked. Catherine loves them too so we both send you & Felicity our love & thanks for a noble gift.

TO MICHAEL BEHRENS, UNDATED

Edward Ardizzone
130 ELGIN AVENUE, LONDON W9 · CUNNINGHAM 7006

DEAR Michael
What a lovely holiday we have had. The sun;
the surroundings; the company; Maria's cooking &
a sort of happy idleness has added up to something
which was as near perfection as is allowed to
mortal man. Catherine & I loved every moment
of it & we send our love & thanks to both you
& Felicity.
 Ted

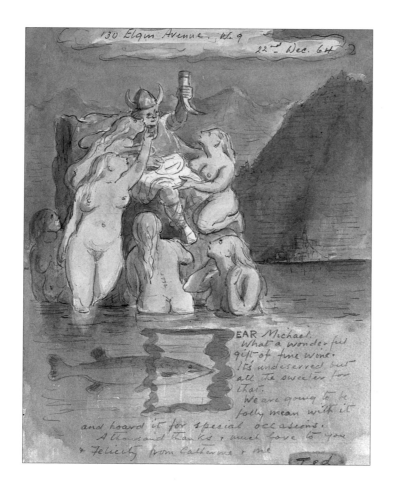

130 Elgin Avenue. W. 9

22nd Dec. 64

DEAR Michael.
What a wonderful
gift of fine wine.
Its undeserved but
all the sweeter for
that.
We are going to be
jolly mean with it
and hoard it for special occasions.
A thousand thanks + much love to you
+ Felicity from Catherine + me

Ted

74 TO MICHAEL BEHRENS, 1964

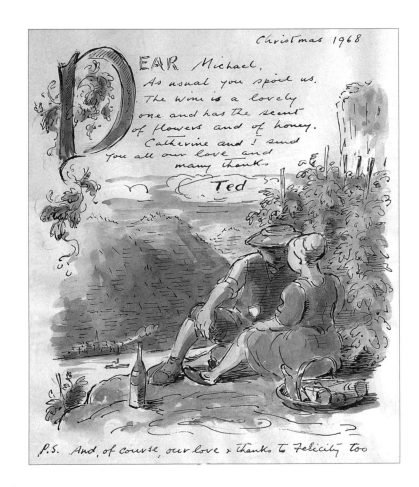

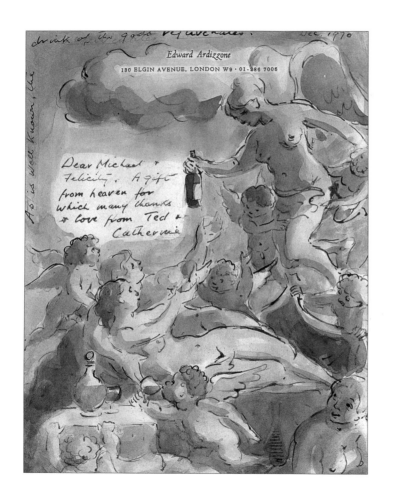

TO MICHAEL BEHRENS, 1970

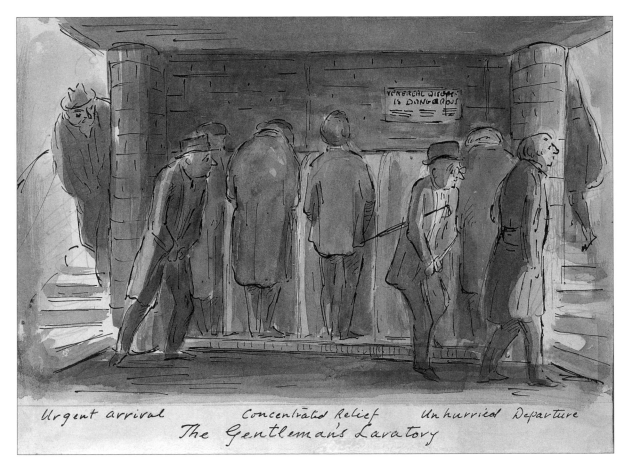

Urgent arrival Concentrated Relief Unhurried Departure

The Gentleman's Lavatory

TO JULIA AND TED WHYBREW, UNDATED

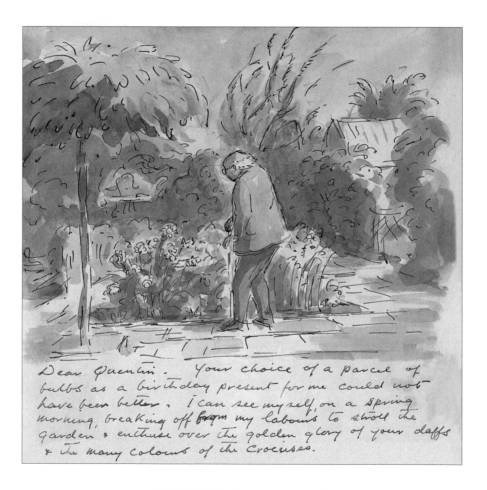

Dear Quentin. Your choice of a parcel of bulbs as a birthday present for me could not have been better. I can see myself on a spring morning, breaking off from my labours to stroll the garden & enthuse over the golden glory of your daffs & the many colours of the crocuses.

TO QUENTIN CLEMENCE, 1973

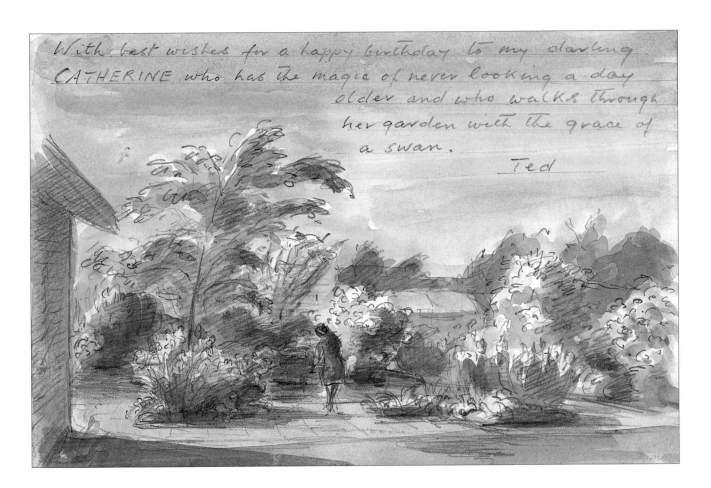

With best wishes for a happy birthday to my darling
CATHERINE who has the magic of never looking a day
older and who walks through
her garden with the grace of
a swan.
Ted

TO CATHERINE ARDIZZONE, C.1974

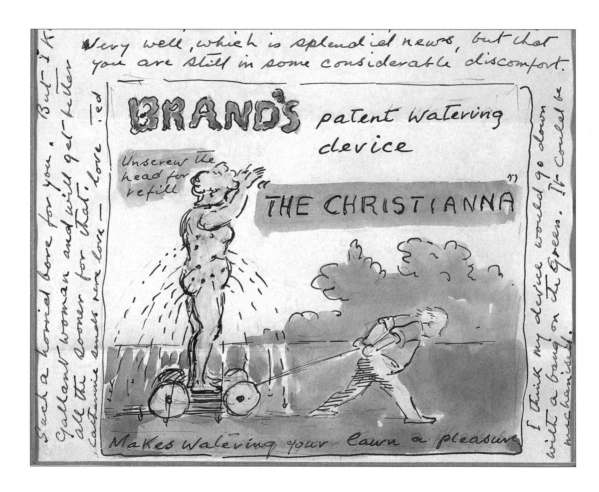

TO CHRISTIANNA BRAND, 1975

Visiting Dieppe — A Selection

1951

FRIDAY 25th

*We [Edward and David Ardizzone
and Barnett Freedman] catch the
boat train — No accidents and an
easy get away.*

*The sea very rough but our
pills work. Drink much
whisky in the bar....*

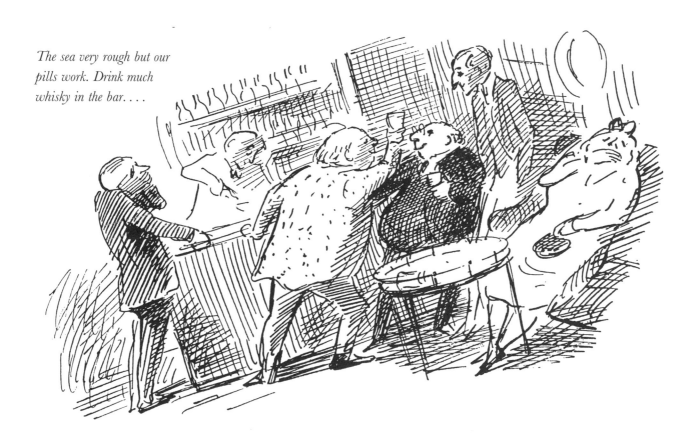

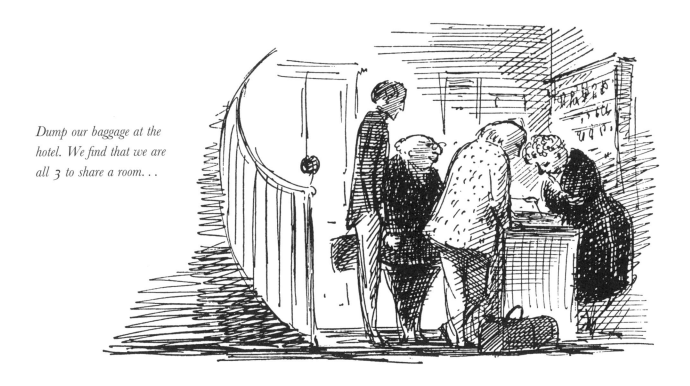

Dump our baggage at the hotel. We find that we are all 3 to share a room...

84

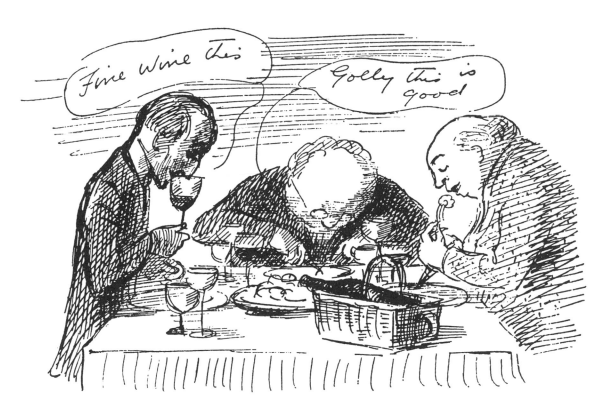

A splendid dinner —
Saucisson — Lobster Mayonnaise — Roast Chicken — Salade —
Roquefort and to drink — Vin d'Alsace & a Corton 43....

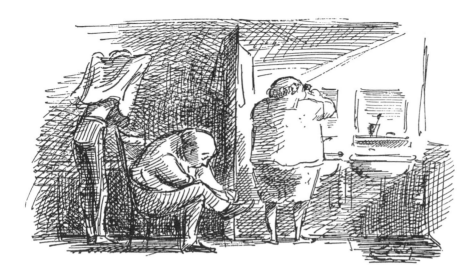

SAT 26th Get up in a leisurely way...

Aperitifs at the 'Tribuneaux'...

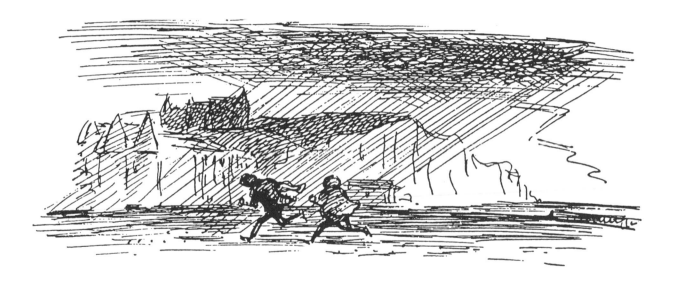

Later David and I bathe and are caught in a tremendous thunderstorm. . . .

SUNDAY 27th

Gastronomically a splendid day.
A simple lunch — Steak and
salade, but with a fine wine —
Château Talbot 29

88

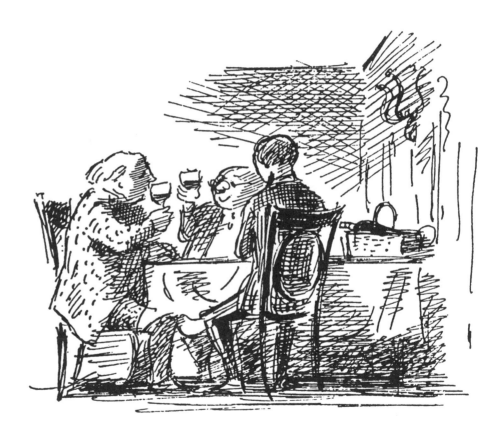

MONDAY 28th
Our last and our most active
day. Shopping in the morning
with an amusing interlude
in an antique shop....
The rognons for lunch
were delicious.

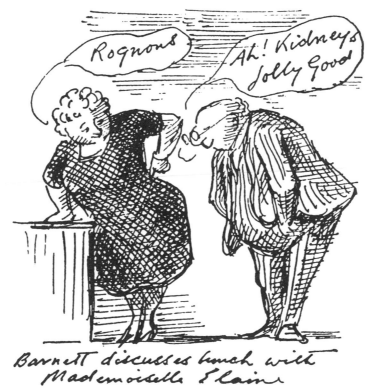

Barnett discusses lunch with
Mademoiselle Elaine

The [proprietor's] wife told me with such assurance
that my snuff would collect in a ball behind my forehead
and destroy my wits, that I felt quite alarmed. . . .

In the afternoon David & I visit an exhibition in the Castle and see some nice fourteenth century stone carvings, objects in ivory & one good early Sickert but badly framed. . . .

91

The End

SKETCHES FROM LETTERS

1954–1959

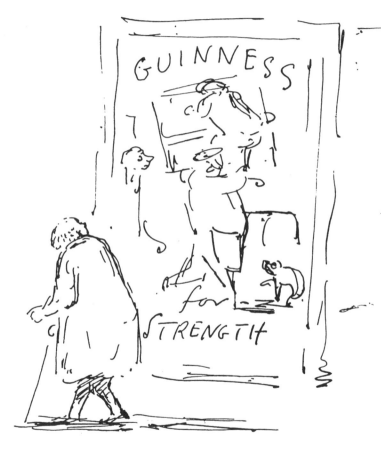

94

*London is now plastered with my Guinness posters
— a positive rash of them and I creep round feeling
rather ashamed of myself. The multiplicity is over-
powering and destroys what little virtue there may
be in the job.*

TO CHRISTIANNA CLEMENCE, 1954

*Here is the small drawing I promised you
for your copy of "The Little Bookroom."
You see I have depicted myself being kind
to children. I fear I am not really so.*

TO EILEEN COLWELL, 1955

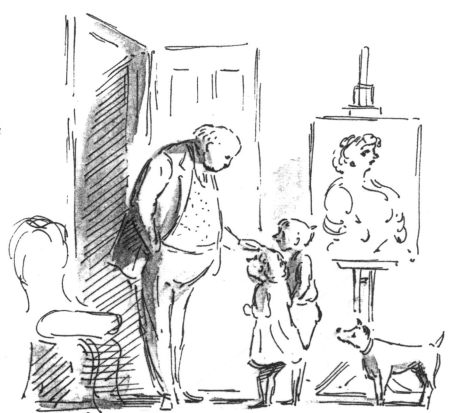

95

96

I have just returned from the City where I have been tasting and buying wine for the college [Royal College of Art]. A job I always find exciting.

TO JOSE BAIRD, 1955

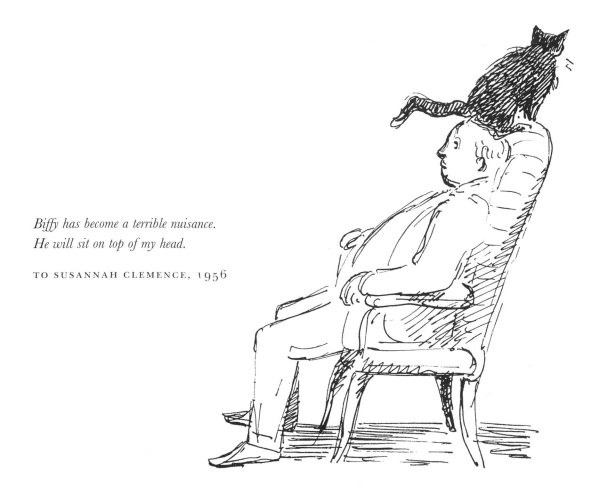

Biffy has become a terrible nuisance.
He will sit on top of my head.

TO SUSANNAH CLEMENCE, 1956

97

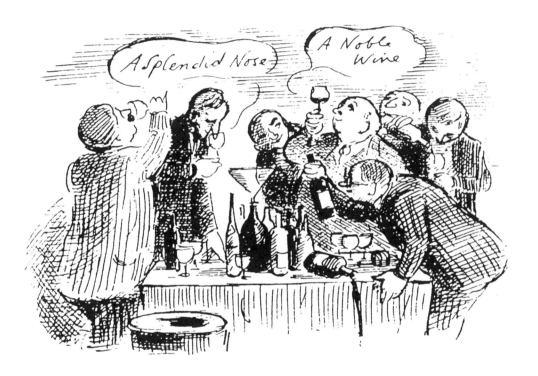

A few days ago your Committee laid out nearly £500 for the benefit of our Cellar.

ROYAL COLLEGE OF ART CELLAR NOTES, 1956

*I am delighted to hear that the Quixote idea
may bear fruit. . . . It will be fun to do and
I am already illustrating it in my mind.*

99

I look forward to the Surtees job [Hunting
with Mr Jorrocks] *and in fact have been
practising drawing horses for it.*

TO JOHN BELL, 1956

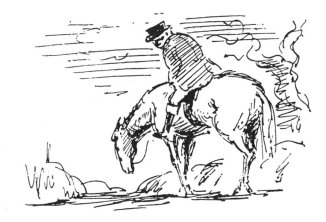

Delighted to hear I now wear the mantle of
Kate Greenaway. You may expect me in
this guise at any moment.

TO JOHN BELL, 1957

[EA was awarded the 1956 Kate Greenaway Medal for *Tim
All Alone*, "The most distinguished work in the illustration of
children's books" published during the preceding year.]

I have just come back from the pub where old women are rather solemnly dancing "Knees Up Mother Brown."

TO ROGER MORRIS, 1957

On *1st reading* [The Penny Fiddle]
I visualise the 1910s; sailor suits,
straw hats and girls white and bunchy
with black stockings.

TO ROBERT GRAVES, 1959

A Day Out at Glyndebourne
1960

Royal College of Art Supplementary Wine Notes, 1960

The Wine Committee had a splendid day out. We visited Glyndebourne...

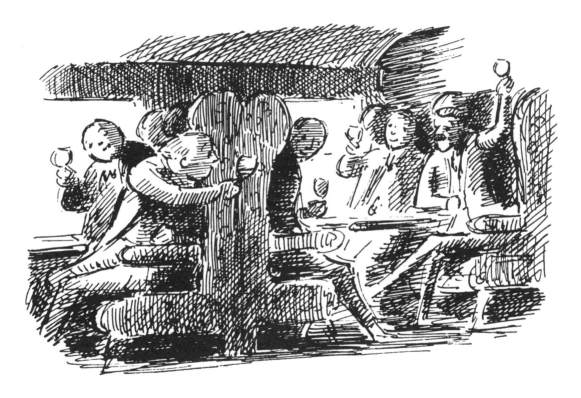

As the train moved out of the station a bottle of Champagne was opened for us.
I can imagine no better start to a festive day.

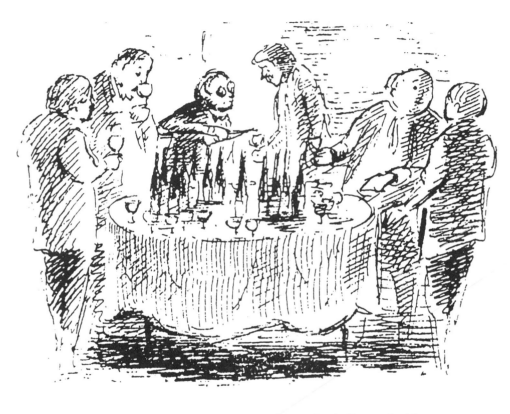

A round table in the corner of the main dining hall covered with a forest of tall bottles & glasses marked the scene.

The Glyndebourne General Manager, who was our host, took us on a tour of the back stage activities. Stage hands busy among the tall stands of scenery...

. . . seamstresses stitching costumes; wigmakers and property makers.

The tour was followed by a quiet session in the garden.

At 5:00 p.m. we changed into evening clothes. . . .
There were two bottles of Champagne to sweeten the task.

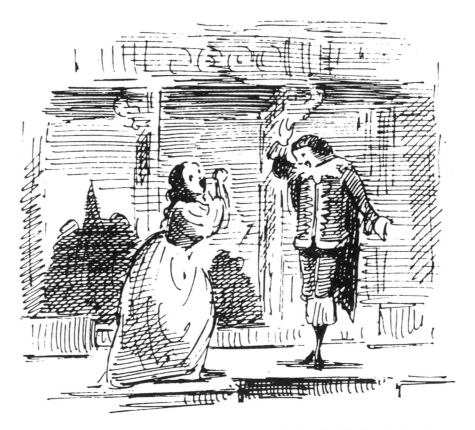

The opera of the evening was Bellini's "I Puritani" in which the fine signing of Joan Sutherland and the pretty tuneful music gave us all much pleasure.

The End

Sketches from Letters

1962–1976

*The other day, surrounded by grandchildren, I knocked off an impromptu story
which proved a "wow". Even the parents were spell bound.*

TO GRACE HOGARTH, 1962

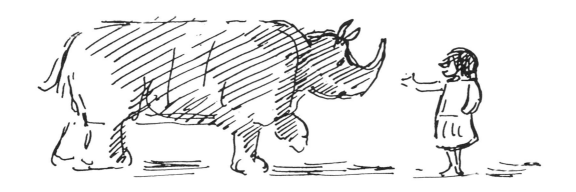

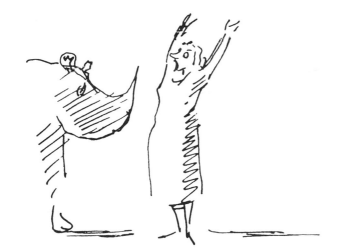

I am writing a story about a Rhinoceros and a girl called Diana. Diana's mother was very frightened of it and went "ooee ooee" and fell on the floor.

TO JOANNA ARDIZZONE, 1962

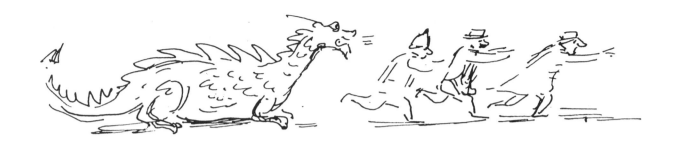

Here is a picture of a very naughty dragon. . . . It breathed fire at a baker, a butcher and a policeman and they all ran away. . .

114

Then he breathed fire at a boy. The boy was very brave. He knew all about dragons. . .

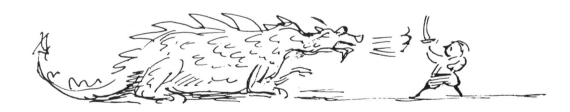

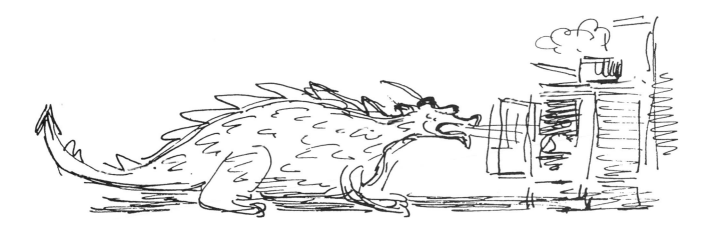

*. . . He breathed fire at the pot of potatoes on the cooker
and it boiled away merrily; and he breathed fire
into the oven and the joint cooked at once.*

TO DANIEL ARDIZZONE, 1966

116

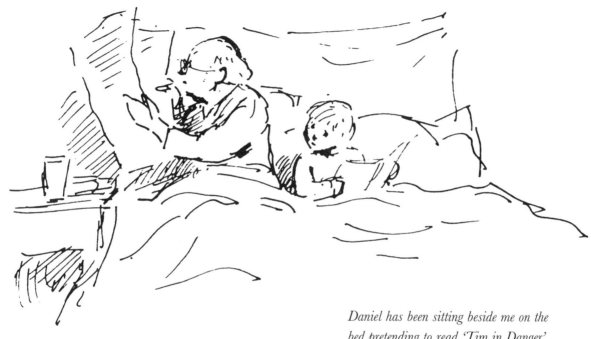

*Daniel has been sitting beside me on the
bed pretending to read 'Tim in Danger'
to me, while I have been trying hard
to read 'The Times'.*

TO JOANNA ARDIZZONE, 1965

Your gift of champagne arrived as a godsend. . . . It is delicious
to drink and has put up my stock with the nurses.

TO MICHAEL BEHRENS, 1967

The move down [to Rodmersham Green] was painless,
but the settling in anything but. It still goes on. Books alone
are a nightmare. I have too many and owing to a miscalcu-
lation I have not enough shelves to put them on.

TO JUDY TAYLOR, 1972

118

This place [Canterbury Hospital] is a kind of benevolent Hell.
One is surrounded by the sweetest little angels. Alas one can't see their wings
and if you could I fear some would be dark and hooked.

TO MICHAEL BEHRENS, 1975

*I am bathed each week by the district nurse which can add a
certain element of Drama.*

TO COLIN WHITE, 1976

120

*Each morning I go to the studio wearing
my butcher's apron.*

TO CHRISTIANNA CLEMENCE, 1976

Snodgrass Letters

1960–1968

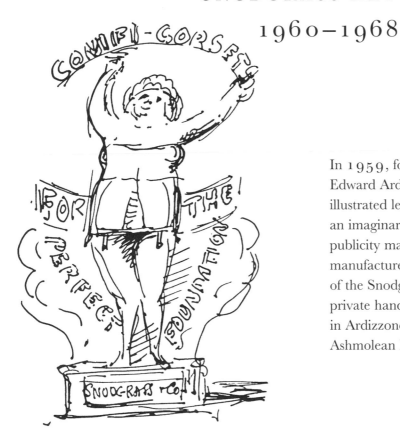

In 1959, for his own amusement,
Edward Ardizzone began a series of
illustrated letters to Mr Snodgrass,
an imaginary (and extremely inefficient)
publicity manager for a firm of corset
manufacturers, Comfi-Corsets. Some
of the Snodgrass Letters are now in
private hands but others can be seen
in Ardizzone's later sketchbooks in the
Ashmolean Museum.

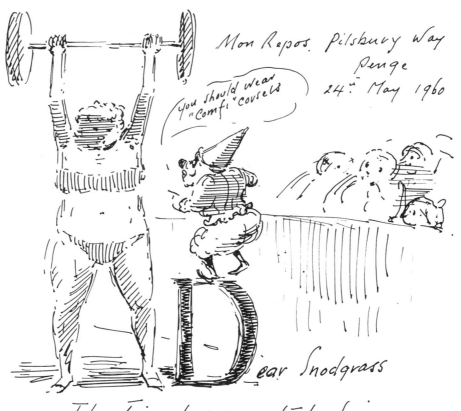

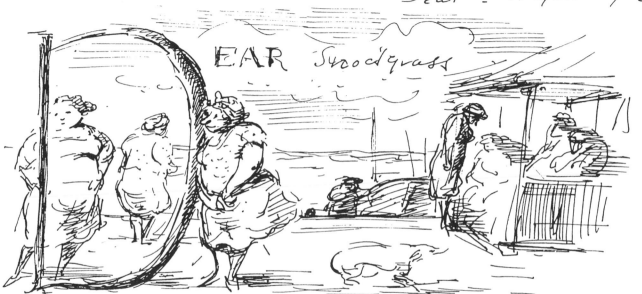

Deal - August 1913

DEAR Snodgrass

123

The wind which flutters the skirts
of the local ladies & moulds in their
cloth of their summer dresses to display
a rotundity of form made me suppose

Mon Repos, Coulsdon
Surrey
16ᵗʰ Feb. 1965.

My dear Snodgrass
I am perturbed by the
latest designs you
have sent me.
How often have I
said before, & you pay
little heed to it, our
advertising should be
poetic not realistic, nor,
in the highbrow sense, if
there is any sense in it,
artistic. Neither Rubens, Renoir

nor Picasso have any appeal to the mums who
buy our Comfi Corsets. Glamour is what
they want. Persuade them that when their soft
flesh, delightfully soft mind you, is held firmly,

with the most delicate restraint, in one of our foundation garments they will be as 15 rather than 55, & ripe for the tennis court, dance hall & the lover. Though this latter must be only hinted at. Never forget we have a most respectable clientèle.

New designs please & soon
 Yours with
some displeasure
 Ernest Banks

How beautifully you dance

Thanks — Yes Thanks to Confi Corsets

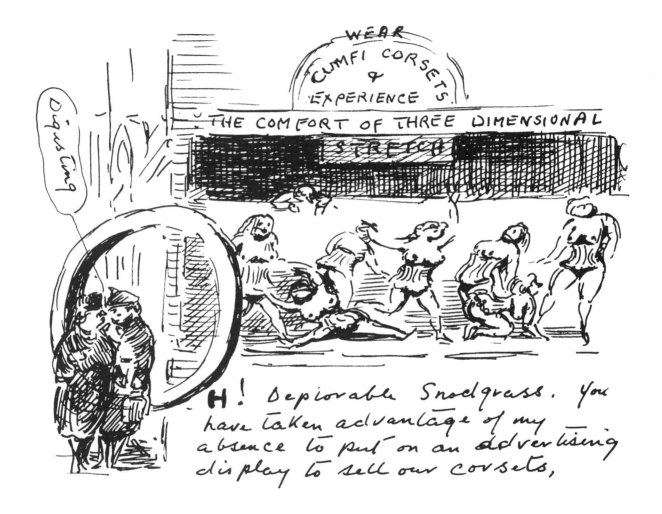

and above all to display the unique
qualities of our THREE DIMENTIONAL
STRETCH. But our clients are respectable
ladies & do not
approve of nudes
& semi nudes.
 Think more
on these lines →
 Yours in much
displeasure
 Jos. Binks

EDITOR'S ACKNOWLEDGMENTS

My grateful thanks to everyone who sent me copies of the Ardizzone letters in their possession and, in particular, to those who gave me permission to reproduce the chosen sketches: all the members of the Ardizzone family, together with Jose Baird, Catherine Barron, Felicity Behrens, John Bell, Eileen Colwell, Beryl Graves, Audrey Harris, Michael Irwin, Roland Lewis, Roger Morris, the Royal College of Art, the University of Southern Mississippi de Grumond Collection, Antony White, Colin White, and Julia and Ted Whybrew.

Colour letters photographed by Angelo Hornak

COLOPHON

Sketches for Friends has been set in Monotype Baskerville, a digital version of the types designed and cut by John Baskerville of Birmingham from 1750 onwards. Although he is now viewed as one of the major figures in the history of printing, Baskerville's success as a designer of letters and printer of books was limited in his homeland, where the types of William Caslon held sway until well into the nineteenth century. So dire was the state of Baskerville's reputation that his types, punches, and matrices were sold by his widow to the French playwright Beaumarchais in 1780. Baskerville's types enjoyed far more success on the Continent, where they would influence typographers of the caliber of Fournier, the Didots, and Bodoni. The types began to enjoy genuine success early in the twentieth century, when designers like Bruce Rogers and Daniel Berkeley Updike began to produce books from types cast from the original matrices in Paris, and their place became secure when they were recut for machine composition by the Monotype Corporation, under the direction of Stanley Morison.

Design and composition by Carl W. Scarbrough

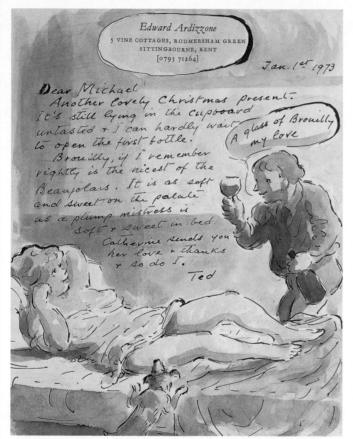

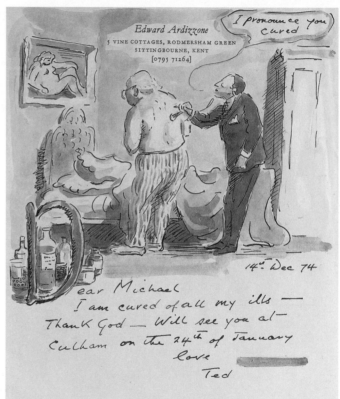